TO COLLECTORS AND OWNERS OF PICTURES

If you wish to

 Buy Pictures (Old or Modern), Sell Pictures (Old or Modern),

Or to have

 Pictures Restored, Pictures Valued, Pictures Identified, Pictures Bought at Sales, Pictures Bought at Exhibitions, Pictures Warehoused, Pictures or Miniatures Copied;

Or

ANY ADVICE ON PICTURES,

Pay a visit to, or write to the Directors

E. Trevelyan Turner, Sir Wm. Bruce, Bart., J.P.

The Carlton Galleries
PALL MALL PLACE, LONDON

Telephone No. 1117 Mayfair. Telegrams "Galerada, London."

ALL GOWANS'S ART BOOKS SUPPLIED
6d. Paper Cover, 1/- Cloth

Where to get Gowans's Art Books abroad.

France.—A. PERCHE, 45 Rue Jacob, Paris, publishes a French edition.

Belgium.—ÉM. GROENVELDT, 13 Rue St-Boniface, Brussels.

Holland.—KIRBERGER & KESPER, Amsterdam. JAS. G. ROBBERS, Amsterdam. SWETS & ZEITLINGER, Amsterdam. A. ABRAHAMS, The Hague.

Italy.—ROSENBERG & SELLIER, 18 Via Maria Vittoria. Turin. F. CASANOVA & Co., Piazza Carignano, Turin. B. SEEBER, 20 Via Tornabuoni, Florence. LIBRERIA LOESCHER & Co., 307 Corso Umberto 1°, Rome. LIBRERIA W. MODES, 146 Corso Umberto 1°, Rome. G. RICCI & Co., Galleria Mazzini 43, Genoa. LIBRERIA STEFANO SERAFIN, Venice. LIBRERIA L. BELTRAMI, Piazza Galvani, Via Farini, Bologna. LIBRERIA E. BONOMI, Galleria Vittoria Emanuele 84, Milan. U. HOEPLI, Galleria de Cristoforis 59, Milan. FRATELLI DRUCKER, Padua.

Switzerland—E. FRANKFURTER, 12 Grand-Chêne, Lausanne.

Scandinavia.—A. & O. SCHEDIN, Lund, Sweden.

Spain and Portugal.—FERREIRA & OLIVEIRA, LDA., Rua do Ouro, 132, Lisbon.

Canada.—MUSSON BOOK CO., LTD., Toronto.

United States.—FREDERICK A. STOKES CO., 443 Fourth Avenue, New York.

Germany.—WILHELM WEICHER, Haberlandstr. 4, Berlin W 30, publishes a German edition.

Finland.—AKTIEBOLAGET AKADEMISKA BOKHANDELN, Helsingfors.

India.—D. B. TARAPOREVALA SONS & Co., Bombay.

PHOTOGRAPHS OF THE MASTERPIECES
OF
PAINTINGS & SCULPTURE

in the Public and Private Collections
of the Nation and on the Continent.

Telegraphic Address:
"Enlargers," London.

Telephone No.
2212 Mayfair.

A CATALOGUE: "Choice Photographs of Choice Pictures." A careful selection of nearly two thousand subjects, with sizes and styles of publication and prices, with 250 Illustrations, post free, 1s.

If you are wanting Art Photographs of any description write to—

W. A. MANSELL & CO.
405 OXFORD STREET,
LONDON, W.

Concise List of twenty other catalogues of Photographs
post free.

GOWANS'S ART BOOKS

Oct. 1st, 1910

The following have already appeared:

THE MASTERPIECES OF	THE MASTERPIECES OF
1. RUBENS	21. FRA ANGELICO
2. VAN DYCK	22. TINTORETTO
3. REMBRANDT	23. POUSSIN
4. RAPHAEL	24. PERUGINO
5. REYNOLDS	25. MICHELANGELO
6. TENIERS	26. GOYA
7. THE EARLY FLEMISH PAINTERS	27. DÜRER
	28. GAINSBOROUGH
8. TITIAN	29. LOTTO
9. FRANS HALS	30. LUINI
10. MURILLO	31. GREUZE
11. WOUWERMAN	32. CARPACCIO AND GIORGIONE
12. VELAZQUEZ	
13. HOLBEIN	33. HOGARTH
14. VERONESE	34. GIOTTO
15. RAEBURN	35. MORETTO
16. DEL SARTO	36. ROMNEY
17. CORREGGIO	37. ORCAGNA, LORENZO MONACO AND MASOLINO
18. BRONZINO	
19. WATTEAU	
20. BOTTICELLI	38. GERARD DOU

LONDON & GLASGOW: GOWANS & GRAY, LTD.

GOWANS'S ART BOOKS

Oct 1st, 1910

Messrs. GOWANS & GRAY ask with confidence for the continued support of this undertaking by lovers of art. It is their hope to be able to cover the whole field of classic painting by including all important artists who were born before the year 1800, and the preparation of new volumes is being carried on steadily and systematically with this end in view.

As new editions of earlier volumes are called for, improvements are made when considered advisable; newly discovered pictures are inserted, and opportunity is taken to discard inferior pictures if others of superior merit are found to be obtainable.

The publishers hope to accelerate the issue of the series by publishing future volumes at the rate of at least twelve yearly, and their efforts will be very much assisted if those who appreciate the books will place standing orders, "till further notice," with their booksellers.

They beg to announce the following, with approximate dates of issue:

39. THE MASTERPIECES OF BOUCHER
 [*Oct.*, 1910
40. THE MASTERPIECES OF CONSTABLE
 [*Oct.*, 1910
41. THE MASTERPIECES OF UCCELLO, VENE-ZIANO, MASACCIO, AND CASTAGNO
 [*Oct.*, 1910
42. THE MASTERPIECES OF JAN STEEN
 [*Oct.*, 1910
43. THE MASTERPIECES OF CLAUDE
 [*Nov.*, 1910
44. THE MASTERPIECES OF MORLAND
 [*Nov.*, 1910
45. THE MASTERPIECES OF LIPPI [*Nov.*, 1910

Others in Preparation.

Price of each volume:
in parchment cover, 6d net; in cloth, 1s net;
in leather, 2s net; postage, 1d extra

LONDON & GLASGOW: GOWANS & GRAY, LTD.

Now Ready. Pape Cover, 1s. *net (postage* 2d. *extra);*
Cloth, 1s. 6d. *net: Leather,* 2s. n t *(postage* 3d. *extra).*

TURNER'S
"LIBER STUDIORUM"

MINIATURE EDITION

Containing, not only the 71 published plates, but also reproductions of all the unpublished plates as the artist left them.

This little volume is indispensable to all readers of Ruskin. It does what has never been done before, it provides reproduction of the unpublished plates which Ruskin often refers to, and it does this at a price unprecedented for cheapness. The illustrations are printed in our best style on the finest of papers.

GOWANS & GRAY, LTD., LONDON & GLASGOW

THE TALES
OF
THEODOR STORM

The Publishers wish to call the attention of readers to five tales (never previously translated) by Theodor Storm, author of the world-famous "Immensee," which are published in English in "Gowans's International Library."

They are: 1. "Eekenhof"; 2. "A Chapter in the History of Grieshuus"; 3. "Renate"; 4. "A Festival at Haderslevhuus" and 5. "*Aquis Submersus.*"

These beautiful stories are obtainable at Sixpence net each, in pretty parchment covers. "Immensee" is also issued by the same publishers in a different *format* at the same price.

GOWANS & GRAY, LTD., London & Glasgow

ESTABLISHED 1854.

By Special Appointment

Telephone:
No. 195 VICTORIA

Cable Address:
"REWOP"

For the Colonies
and U.S.A.

Works and Studios:
RUSKIN HOUSE,
ROCHESTER
ROW,
WESTMINSTER

W. M. POWER, M.R.S.A.,

FRAME SPECIALIST
AND PICTURE PRESERVER,

whose artistic connection with the City of Westminster dates back over half a century, has since 1902 been the recipient of the following Royal Appointments and other honours, viz.:

H.R.H. Prince of Wales, 1902.
H.M. King Edward VII., 1907.
H.R.H. Princess of Wales, 1908.
H.M. Queen Alexandra, 1909.
H.M. King George V., 1911.
H.M. Queen Mary, 1911,

and re-appointed to H.M. Queen Alexandra, 1911.

Grand Prix, Franco-British Exhibition, 1908
Hors Concours a a Expert Member of International Jury,
Brussels, 1910

SPECIALITIES—

The Restoration and Preservation of Valuable Paintings, Drawings and Old Engravings.

Damp spots, mildew, etc., removed from Miniatures on Ivory.

Old Frames and Furniture re-gilt in such a manner as to retain their antique appearance.

VICTORIA GALLERIES,
123 VICTORIA STREET, WESTMINSTER,
LONDON, S.W,

A few doors west of Army and Navy Stores

NINETEENTH CENTURY ART BOOKS, No. 1

MASTERPIECES OF G. F. WATTS

R. MACLEHOSE AND CO. LTD., PRINTERS, GLASGOW
BLOCKS BY HISLOP AND DAY, EDINBURGH
PAPER BY ALEX. COWAN AND SONS, LTD., EDINBURGH

PORTRAIT OF HIMSELF PORTRAIT DE L'ARTISTE
 SELBSTBILDNIS
 (*Tate Gallery, London*)
 F. Hollyer, Photo.

MASTERPIECES

OF

G. F. WATTS

(1817-1904)

Sixty reproductions of photographs by Fredk. Hollyer from th original oil paintings: special permission for their publication in this book has been kindly accorded by Mrs. Watts

GOWANS & GRAY, Ltd.
5 Robert Street, Adelphi, London, W.C.
58 Cadogan Street, Glasgow
1911

First Edition, June, 1911. Second Edition (with corrections or additions on pp. 8, 16, 19-21, 37, 40, 42, 44-48, 50, 52, 53, 56, 58-60, 62, 63), December, 1911.

IN the first edition of the little book there were a number of errors, owing principally to the fact that Mr. Watts often painted more than one version of the same subject. A drawing was also reproduced by mistake. In this second edition every effort has been made to eliminate mistakes and the particulars now given as to the present whereabouts of the paintings can be relied upon as correct and up to date.

This is the first volume of a companion series to the well-known " Gowans's Art Books," which are confined to artists born before 1800. The attention of all lovers of art is directed to the latter series, and their support of an enterprise, which has done so much to make the best art better known in all parts of the world, is earnestly requested.

LORD TENNYSON
(*National Portrait Gallery, London*)
F. Hollyer, Photo.

ROBERT BROWNING
(National Portrait Gallery, London)
F. Hollyer, Photo.

THOMAS CARLYLE
(*Victoria and Albert Museum, South Kensington*)
F. Hol'yer, Photo.

GEORGE MEREDITH
(*National Portrait Gallery, London*)
F. Hollyer, Photo.

WILLIAM MORRIS
(*National Portrait Gallery, London*)
F. Hollyer, Photo.

JOHN LOTHROP MOTLEY
(Art Gallery, Manchester)
F. Hollyer, Photo.

CONDOTTIERE
(*Watts Gallery, Compton, Guildford*)
F. Hollyer, Photo.

THE STANDARD-BEARER LE PORTE-ÉTENDARD
DER STANDARTENTRÄGER
(*Watts Gallery, Compton, Guildford*)
F. Hollyer, Photo.

The wounded Heron Le Héron blessé
Der verwundete Reiher
(Watts Gallery, Compton, Guildford)

MIDDAY REST (DRAY HORSES) REPOS DU MIDI (CHEVAUX DE HAQUET)
MITTAGSRUHE (KARRENGÄULE)
(Tate Gallery, London) F. Hollyer, Photo.

"I'm Afloat" "Ich bin flott" "Je flotte"
(*Mr. James Smith, Liverpool*)
F. Hollyer, Photo.

"Good Luck to your Fishing" "Bonne Chance dans votre Pêche"
"Glück auf Ihr Fischen"
(Lord Glenconner, London) F. Hollyer, Photo.

IDLE CHILD OF FANCY VAIN ENFANT DE LA FANTAISIE
EITLES KIND DER PHANTASIE
(*Watts Gallery, Compton, Guildford*)
F. Hollyer. Photo.

DAWN TAGESANBRUCH L'AURORE
*(Recently in the possession of Messrs. Gooden
& Fox, London)*
F. Hollyer, Phot.

ASPIRATION DAS EMPORSTREBEN L'ASPIRATION
(*Mr. John T. Middlemore, Bromsgrove*)

PROGRESS DER FORTSCHRITT LE PROGRÈS
(*Watts Gallery, Compton, Guildford*)
F. Hollyer, Photo.

INDUSTRY AND GREED L'INDUSTRIE ET L'AVARICE
GEWERBEFLEISS UND HABGIER
(Watts Gallery, Compton, Guildford)
F. Hollyer, Photo.

MAMMON
(Tate Gallery, London)
F. Hollyer, Photo.

THE SPIRIT OF CHRIS- L'ESPRIT DU CHRIS-
 TIANITY TIANISME
 DER GEIST DES CHRISTENTUMS
 (Tate Gallery, London) F. Hollyer, Photo.

The Dweller in the L'Habitant des Régions
Innermost Intérieures
Der Bewohner im Innersten
(*Tate Gallery, London*) F. Hollyer, Photo.

THE ALL PERVADING QUI SE RÉPAND DANS TOUT
DER ALLDURCHDRINGENDE
(*Tate Gallery, London*) F. Hollyer, Photo.

LIFE'S ILLUSIONS LES ILLUSIONS DE LA VIE
DIE ILLUSIONEN DES LEBENS
(*Tate Gallery, London*)
F. Hollyer, Photo.

LOVE AND LIFE L'AMOUR ET LA VIE
 LIEBE UND LEBEN
 (*Tate Gallery, London*) *F. Hollyer, Photo.*

Love and Death L'Amour et la Mort
Liebe und Tod
(Tate Gallery, London) F. Hollyer, Photo.

LOVE TRIUMPHANT L'AMOUR TRIOMPHANT
 TRIUMPHIERENDE LIEBE
 (Tate Gallery, London) F. Hollyer, Photo.

THE SHUDDERING ANGEL. L'ANGE QUI FRISSONNE
DER SCHAUDERNDE ENGEL.
(Watts Gallery, Compton, Guildford) F. Hollyer, Photo.

THE MESSENGER LE MESSAGER
DER ABGESANDTE
(Tate Gallery, London) F. Hollyer, Photo.

THE HAPPY WARRIOR LE GUERRIER HEUREUX
(*New Pinacotheca, Munich*) (*Nouvelle Pinacothèque, Munich*)
DER GLÜCKLICHE KRIEGER
(*Neue Pinakothek, München*)
F. Hollyer, Photo.

DEATH CROWNING 	LA MORT COURONNANT
INNOCENCE 	L'INNOCENCE
DER TOD KRÖNT DIE UNSCHULD
(Tate Gallery, London) F. Hollyer, Photo.

THE COURT OF DEATH　　　　LA COUR DE LA MORT
DER HOF DES TODES
(Tate Gallery, London)　　F. Hollyer, Photo.

"Sic Transit Gloria Mundi"
(Tate Gallery, London)
F. Hollyer, Photo.

TIME, DEATH AND JUDGE- LE TEMPS, LA MORT ET LE
 MENT JUGEMENT
 ZEIT, TOD UND GERICHT
 (St. Paul's Cathedral, London) F. Hollyer, Photo.

FAITH DER GLAUBE LA FOI
(*Tate Gallery, London*)
F. Hollyer, Photo.

Hope Die Hoffnung L'Espérance
(Tate Gallery, London)
F. Hollyer, Photo.

CHARITY DIE BARMHERZIGKEIT LA CHARITÉ
 (*Mr. John Reid, Glasgow*)
 F. Hollyer, Photo.

"She shall be called Woman" "Celui-ci s'appellera d'un nom qui marque l'Homme"
"Man wird sie Männin heissen"
(Tate Gallery, London) F. Hollyer, Photo.

Eve Tempted Ève Tentée
Eva in Versuchung
(*Watts Gallery, Compton, Guildford*) F. Hollyer, Photo.

EVE REPENTANT ÈVE REPENTANTE
DIE BÜSSENDE EVA
(*Tate Gallery, London*) *F. Hollyer, Photo.*

The Meeting of Jacob and Esau

Rencontre de Jacob et d'Ésaü

Begegnung Jakobs mit Esau

(Watts Gallery, Compton, Guildford)

F. Hellyer, Photo.

JONAH JONA JONAS
(Tate Gallery, London)
F. Hollyer, Photo.

THE GOOD SAMARITAN LE BON SAMARITAIN
 DER BARMHERZIGE SAMARITER
(Watts Gallery, Compton, Guildford) F. Hollyer, Photo.

"For he had great Possessions" "Car il avait de grands Biens"
"Denn er hatte viel Güter"
(Tate Gallery, London) F. Hollyer, Photo.

THE RIDER ON THE WHITE HORSE LE CAVALIER SUR LE CHEVAL BLANC
DER REITER AUF DEM WEISSEN PFERDE
(Hon. Alfred Talbot, Gt. Berkhampstead)
F. Hollyer, Photo.

PAOLO AND FRANCESCA PAOLO ET FRANCESCA
PAOLO UND FRANCESCA
(*Watts Gallery, Compton, Guildford*)
F. Hollyer, Photo.

Sir Galahad
(Sir Alex. Henderson, Bart., London)
F. Hollyer, Photo.

OPHELIA OPHELIA OPHÉLIE
(Watts Gallery, Compton, Guildford)
F. Hollyer, Photo.

52

LITTLE RED RIDING-HOOD LE PETIT CHAPERON ROUGE
ROTKÄPPCHEN
(Art Gallery, Birmingham.)
F. Hollyer, Photo.

The Childhood of Zeus L'Enfance de Zeus
Die Kindheit des Zeus

HYPERION
(*Watts Gallery, Compton, Guildford*)
F. Hol'yer, Photo.

PROMETHEUS PROMETHEUS PROMÉTHÉE
(Watts Gallery, Compton, Guildford)
F. Hollyer, Photo.

36

ENDYMION
(Lord Glenconner, London)
F. Hollyer, Photo.

PSYCHE
(Tate Gallery, London)
F. Hollyer, Photo.

DAPHNE
(... R. H. Lever, Bart., Thornton Hough)
F. Hollyer, Photo.

GANYMEDE GANYMED GANYMÈDE
(*Mr. Henry F. Makins, London*)
F. Hollyer, Photo.

ORPHEUS AND EURYDICE ORPHEUS UND EURYDICE ORPHÉE ET EURYDICE
(Hon. Percy Wyndham, London)

THE MINOTAUR DER MINOTAUR LE MINOTAURE
(Tate Gallery, London)
F. Hollyer, Photo.

ARIADNE IN NAXOS ARIADNE AUF NAXOS ARIANE DANS L'ILE DE NAXOS
(Mr. C. Morland Agnew, London)
F. Hollyer, Photo.

Pygmalion's Wife La Femme de Pygmalion
Pygmalions Frau
(*Sir Alex. Henderson, Bart., London*)
F. Hollyer, Photo.

A BACCHANAL. EIN BACCHANAL. UNE BACCHANALE
(*Watts Gallery, Compton, Guildford*)
F. Hollyer, Photo.

SPECIAL SERIES
OF
REPRODUCTIONS IN COLOURS
OF PICTURES

BY THE LATE
G. F. WATTS, R.A., O.M., ETC.

Printed and Published at the Watts Picture Gallery,
Compton, Guildford, under the
SUPERVISION OF Mrs. G. F. WATTS

*All orders and communications should be addressed to the
Curator, Watts Picture Gallery, Compton, Guildford*

PRINTS IN COLOURS NOW READY
Price, £3 3 0 each
Printed upon Japanese Paper

"HOPE"
 Engraved surface 20½" by 16".
 (After the picture in the Tate Gallery.)

"LOVE TRIUMPHANT"
 Engraved surface 23" by 13".
 (After the picture in the Tate Gallery.)

"ENDYMION"
 Engraved surface 20" by 17".
 (After the picture in the Watts Gallery at Compton.)

"LOVE AND DEATH"
 Engraved surface 23" by 13".
 (After the picture in the Tate Gallery.)

PRINTS IN COLOURS—Continued

"FOR HE HAD GREAT POSSESSIONS"
Engraved surface 20" by 11".
(After the picture in the Tate Gallery.)

"SIR GALAHAD"
Engraved surface 24" by 13".
(After the picture at Eton College.)

"LOVE AND LIFE"
Engraved surface 23" by 13".
(After the picture in the Tate Gallery.)

"EVE TEMPTED"
Engraved surface 24½" by 10⅞".
(After the picture in the Tate Gallery.)

"EVE REPENTANT"
Engraved surface 24½" by 10⅞".

"SHE SHALL BE CALLED WOMAN"
Engraved surface 24½" by 10⅞".

"AFLOAT"
Engraved surface 19" by 15¼".
(After the picture in the Collection of James Smith, Esq.)

"GOOD LUCK TO YOUR FISHING"
Engraved surface 19" by 15½".
(After the picture in the Collection of Lord Glenconner.)

"DEATH CROWNING INNOCENCE"
Engraved surface 24¼" by 15½".
(After the picture in the Tate Gallery.)

"LORD TENNYSON"
Engraved surface about 14" by 10".
(After the picture in the Collection of Lady Henry Somerset.)

Price, £2 2 0

PRINTS IN COLOURS—Continued

"HEAD OF CHRIST"
(From a drawing in the Gallery at Compton.)
Price, £1 11 6

SMALL PRINTS
Price, 10/6 each.

"HOPE"
Printed surface 7" by 5½".

"HE HAD GREAT POSSESSIONS"
Printed surface 8" high.

"SIR GALAHAD"
Printed surface 8" high.

Others will probably follow.

THE WATTS PICTURE GALLERY,
COMPTON LANE

Railway Stations—Guildford, Farncombe, Godalming. Distance under three miles.

PICTURES AND SCULPTURE
by the late G. F. WATTS, R.A., O.M.

Open Daily, Thursdays excepted.

PICTURE GALLERY—

In Summer, from 10 o'clock till 6 o'clock.
In Winter, from 10 o'clock till dusk.
Sundays, from 2 o'clock:

SCULPTURE GALLERY—

In Summer, from 2 o'clock till 6 o'clock.
In Winter, from 2 o'clock till dusk.

On Wednesday, Saturday, and Sunday, and on Bank Holidays. Entrance Free.

On Monday, Tuesday, and Friday. Entrance One Shilling.

The Gallery is closed on Thursday.

CHARLES H. THOMPSON,
Curator.

The following photographs of Mr. Watts's pictures are published and sold by

FREDERICK HOLLYER,

9 Pembroke Square,

Kensington, London, W.

Printed in Sepia Platinotype.

Average size, 12" by 10". Price Unmounted, £0 7 6
 ,, ,, 20" by 16". ,, ,, £0 15 0
 ,, ,, 33" by 19". ,, ,, £2 2 0

Dated 5th February, 1896.

Extract from Agreement

BETWEEN

GEORGE FREDERICK WATTS, Esq., R.A., O.M.,

AND

FREDERICK HOLLYER.

CLAUSE 4.—"The said Frederick Hollyer shall before publishing any new photograph of the said pictures and portraits during the lifetime of the said George Frederick Watts submit a proof of such photograph to the said George Frederick Watts, who shall have absolute power to forbid the publication of such photograph if in his opinion the same is inartistic or is for any other reason an unsatisfactory reproduction."

Prometheus.	Mid-day Rest.
Esau.	Condottierre.
The Good Samaritan.	Aspirations.
Idle Child of Fancy.	Ophelia.
The People who sat in Darkness.	The Happy Warrior.
	Europa.

G. F. WATTS'S PICTURES—Continued

Ariadne in Naxos.
Hope.
Good Luck to your Fishing.
Arcadia.
Fata Morgana.
Eve. "She shall be called Woman."
Eve. Tempted.
Eve. Repentant.
The Messenger.
Death of Abel.
Court of Death.
Time, Death, and Judgment.
Childhood of Zeus.
"When Poverty comes in at the Door."
Britomart.
Progress.
Orpheus and Eurydice.
Ariadne.
B.C.
Mammon.
The Minotaur.
Daphne.
Psyche.
Love and Death.
Love and Life.
"The Rain it Raineth every Day."
Endymion.
Ganymede.
A Prodigal.
The Dweller in the Innermost.
Dedicated to all the Churches.
Hyperion.
Lady Godiva.
The Schoolmaster's Daughter
Charity.
A Bacchante.
The Prodigal Son.
Standard Bearer.
Little Red Riding-Hood.
Chaos.
After the Deluge.
Death crowning Innocence.
The Rider on the White Horse.
Study—Aspiration.
Study—Hyperion.
Uldra.
Bay of Naples.
St. Agnese, Mentone.
"For he had great possessions."
Sir Galahad.
"Sic transit gloria mundi."
Ida on Mount Olympus.
The Dove that returned in the Evening.
Iris.
Paolo and Francesca.
Love Triumphant.
Sympathy.
Faith.
Peace and Goodwill.
In the Land of Weissnichtwo.
The Rider on the Red Horse.
The Habit doesn't make the Monk.

G. F. WATTS'S PICTURES—Continued

Pygmalion's Wife.
Samson.
Una and the Red Cross Knight.
Jonah.
Neptune's Horses (printed in blue carbon).
Dawn.
The Dove that returned not again.
The Sorrowing Angel—a Dedication.
Industry and Greed.
Trifles light as Air.
Slumber of the Ages.
The All-Pervading.
Love steering the Barque of Humanity.
Life's Illusions.

Prayer.
Energy (statue).
Whence—Whither?
A Story from Boccaccio.
Time and Oblivion.
Lilian.
"I'm afloat."
Diana and Endymion (1904).
Rider on the Black Horse.
Rider on the Pale Horse.
Italy.
Hebe.
Wife of Plutus.
Bianca.
Destiny.
The Wounded Heron.
The Recording Angel (facsimile in red chalk).

A selection of prints on approval will be sent, if desired, on payment of one shilling to cover cost of packing and postage.

PORTRAITS. PRINTED IN PLATINOTYPE.

Average size, 12½" by 10". Price, £0 10 6
,, ,, 20" by 16". ,, £1 1 0

Argyll, Duke of.
Arnold, Matthew.
Barnett, Rev. S. A.
Bowman, Sir William, Bart.
Brodie, Sir Benjamin, Bart., F.R.S.
Browning, Robert.
Burne-Jones, Sir Edward, Bart.
Calderon, Philip, R.A.
Carlyle, Thomas.
Crane, Walter.
Davey, Lord.
Donders, Professor.
Dufferin, Lord.
Garvagh, Lady.
Gladstone, Right Hon. W. E., M.P.
Grant, Sir Peter.
Guizot, M.
Gurney, Russell.
Holland, Lady.
Joachim, Herr.
Lawrence, late Lord.
Lecky, W. E., late.
Leighton, Sir Frederick, Bart., P.R.A.
Levin, Princess.
Lilford, Lady.
Lytton, the late Earl of.
Manning, Cardinal.
Martineau, Dr.
Meredith, George.
Mill, John Stuart.
Milman, Dean.
Morris, William.
Motley, J. L.
Mount-Temple, Lady.
Napier, General Sir W.
Norton, Hon. Mrs.
Panizzi, Sir Anthony.
Prinsep, V. C., R.A.
Rossetti, Dante Gabriel.
Russell, Lord John.
Salisbury, late Lord.
Senior, Mrs. Nassau.
Shaftesbury, late Earl of.
Sherbrooke, Lord.
Stanley, A. P., Dean of Westminster.
Stephen, Sir Leslie.
Stratford de Redcliffe, Earl.
Swinburne, Algernon C.
Taylor, Sir Henry.
Tennyson, late Lord.
Thiers, M.
Waterford, Louisa, late Marchioness of.
Watts, G. F., R.A., O.M.
Wright, Thomas.

ILLUSTRATED CATALOGUE, including the Works of Sir Edward Burne-Jones, D. G. Rossetti and Harry Bates, R.A.; also selections from the Uffizi, Hague, Dublin and National Galleries, and a large number of portraits of eminent men. Post Free, One Shilling.

Printed in the USA
CPSIA information can be obtained
at www.ICGtesting.com
CBHW051258300624
10893CB00008B/657